THAT
WAS
AWKWARD

THAT WAS AWKWARD

The
Art & Etiquette
of the
Awkward Hug

EMILY FLAKE

VIKING

VIKING

An imprint of Penguin Random House LLC

penguinrandomhouse.com

Copyright © 2019 by Emily Flake

Library of Congress Control Number: 2019947465

ISBN: 9781984879585 (hardcover)

Printed in the United States of America
1 3 5 7 9 10 8 6 4 2

BOOK DESIGN BY LUCIA BERNARD

To Stephney Wallace—I miss your hugs so much.

THAT
WAS
AWKWARD

Introduction

'm a hugger. If allowed, I will hug you upon being introduced, upon parting, upon your having made a particularly good joke. Don't get me wrong, I'm a believer in the power of a good handshake (firm but not aggro, eye contact, no weird finger waggles)—but the hug is my standard as far as physical punctuation goes.

Hugs are a near-universal expression of human emotion. They are a natural outgrowth of the act of holding an infant or child. That sense of security and love is so absolutely fundamental that we seek it even as adults, too big to be lugged around by anybody. Even Disney's Olaf character, the snowman from *Frozen* who would literally die in higher temperatures, longs for "warm hugs." Hugging causes the body to release oxytocin, the so-called trust hormone that floods new mothers as they hold their newborns. It also causes an immediate

reduction in cortisol, the stress hormone behind such impulses as fight-or-flight. When people talk about suffering from touch deprivation, they mean it. It's real.

The word "hug" itself is said to have its roots in the Old Norse word *hugga*, meaning "to comfort." This is ironic, considering the Scandinavian reputation for a certain physical reserve. A Danish friend tells me that her parents' generation would only have hugged someone they'd also take a bullet for, but reports that this seems to be shifting among the youth.

It's not just in Denmark that the norms around hugging seem to have shifted. We no longer live in a world where we can all quote Emily Post chapter and verse, and what qualifies as "good manners" has become increasingly murky. We are a people who will wear leggings as pants. Bereft of a social code and the rituals designed to express it, we are left with a general idea of "being nice" with no particular accepted method of being so. None of us quite know what to do with our bodies when greeting one another. We find ourselves lost in a world full of physical indecision and potential gaffes. Do we shake hands? Do we hug? Do we—horror—kiss on the cheek? Both cheeks? Will I bonk your forehead with mine* because I

* Absolutely. This is my social bête noire—not because I don't want to kiss, but because I am almost certain to screw it up. I am trying to remember to do as Beyoncé commands us and go "to the left," but still, I am just as likely to hurt your face with my face

cannot remember which side I'm supposed to kiss first? Hugs seem kind, they seem friendly—the Mr. Rogers-in-his-home-cardigan-and-sneakers of greetings—but absent widely understood rules on how and where to deploy them, we're likely to screw them up, too.

And so, this book. If we can't agree on a social code anymore, the least we can do is find some warm fellow feelings in our collective confusion. I've bungled a number of hugs, and I bet you have, too. I hope this book serves to let us laugh together at our foibles, and relax enough to remember that the whole point of social niceties is nothing more than putting one another at ease. Now c'mere, you.

or, worse, end up kissing you on the mouth by accident. Again, I am sorry.

Relationships

RECENT EXES,
LONG-TERM RELATIONSHIP

Don't Touch Me, Dear

The ink is still drying on the divorce papers. The books and records are mostly split, except for that one shelf of bathroom reading stuff, and honestly, you can just keep it, CARL. You are, for the moment, seeing the same therapist, but on different days, and only until you can find a new one who takes your bullshit insurance. This is a hug born of a toxic brew of physical force of habit, a desire to keep things civil "for the kids," and a need to do something with your body in the moment other than use it to hit something. If you put spray foam into the space between two bodies engaged in such an embrace, the shape it assumed could be put in a museum and titled *Resentments*.

The saving grace of this hug is its brevity—no time for awkward equivocation here. It is a physical expression of terseness, at once familiar (you do, after all, know this body very well) and repelled (this body did butt stuff with the nanny and you'd just as soon throw it off a cliff). Arms don't go around torsos or necks so much as they form a barrier between the participants while allowing for a brief, vicious clasp-squeeze of the shoulders or waist with the hands. A strangled "bye" muttered between clenched teeth is permissible but not required—after all, haven't you talked each other to death at this point? My *God*, this hug is a bummer.

RECENT EXES, SHORT-TERM RELATIONSHIP

A Hug for the Ghosted

The tone of this hug depends almost entirely on one crucial factor: whether this relationship was ended by ghosting. If it ended civilly and respectfully, with dignity and understanding all around, well, congratulations, you dealt with things like a grown-up. You had the sense to get out of the relationship before it got too serious if you were the dumper, and you were able to handle your disappointment with a measure of grace if you were the dumpee. Chances are good you'll see each other socially from time to time, and you will handle that in a way befitting your easygoing nature and good breeding. You will enjoy a warm, friendly embrace, full of well wishes, and part as friends. Later on, it will occur to you that your friend Sasha from college would be *perfect* for this guy, and you'll ask if you can set them up. Eighteen months later, you attend Sasha's wedding to said guy, and eighteen months after that, they name their firstborn after you. See what good being agreeable can do in this world? I'm so glad everyone here decided to behave reasonably.

HAHAHAHAHA—PSYCH. What planet does that EVER happen on? That dude totally ghosted you, and you owe him NOTHING. NO HUG AT ALL. If you see him flirting, sidle over and let the flirtee know that she's in for a long night of the soul, wondering if maybe her text "just didn't go through" or kicking herself because yes, sending a Facebook message was indeed a bridge too far. UGH, TO HELL WITH THAT GUY.

MARRIED AND DIVORCED OVER A DECADE AGO

Still Crazy After All These Years

Hello, Sheila."

"Hello, Paul."

"You're looking well."

"You're looking good yourself—you always did clean up pretty nicely."

"Well, I have our daughter to thank for that—she's the one who picked out the tuxes."

"Where do you think she got her good taste?"

(*Chuckles.*) "Fair enough. How's Bill?"

"He's doing just fine, thanks. I put him over in the corner—a couple too many martinis, I'm afraid."

"Ah, well, he seemed to have a good time on the dance floor . . ."

"And how's . . . Penny, is it?"

"It's Sage, and she's fine. She's sorry she couldn't make it tonight. She had a presentation in Houston, and—"

"A presentation, eh? Is that what we're calling it now?"

"Now, Sheila, you know she hasn't been a dancer in years—"

"Oooooh, a daaaaancer."

"Exotic is still dancing, Sheila. Anyway, I'm glad to see you've still got your charm."

"Wouldn't you like to know what else I've still got!"

(*Beat.*)

"Meet me in the bathroom in five?"

"You're on, buster."

END SCENE

USED TO BANG IN COLLEGE

My God, You Still Smell the Same

This is a multilayered hug, sort of a parfait of nostalgia, regret, autumnal lust, and judgment, especially if it's been (*cough*) a while since you graduated. This hug is on the longer end of the spectrum, lasting at least long enough for you to size up how much weight your old flame has put on since 1999. Is he no longer that louche, porcelain-skinned dirtbag who seemed half-asleep during crits but was an absolute animal in the bathroom at the underage bar? Is her Louise Brooks bob streaked with gray or, worse, chunky highlights? Remember that one long, delicious, perfect night, when you smoked an entire pack of Old Golds together and finally did it just as the sun came up? And now here you both are, middle-aged AF. Look, the flesh is impermanent, so get in there and wonder what it might have been like if you hadn't dumped him for that contortionist who swore, *swore*, she could get you a girlfriend spot on the circus train, like that hadn't been your dream since you were a child, and then disappeared without so much as a note, and when you looked her up on Facebook she was an evangelical mother of six. Life is a funny old thing, isn't it?

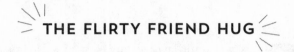

THE FLIRTY FRIEND HUG

Platonic Never Looked So Good

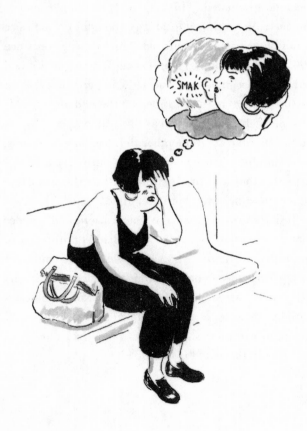

Everyone's got one of these in their social circle: the good-looking, vivacious charmer, the one who locks in when they're talking to you, who lets a small smile play at the corners of their mouth as though you're sharing just the most delicious joke—in short, a flirt. But crucially, this flirt is married or in a committed relationship, and definitely not a cheater— just a person unable to keep their sexy little light under a bushel. Their attentions are flattering but nonthreatening, precisely because they flirt with everyone—a fact that keeps them in the realm of "that's just how X is" and out of the realm of "Oh, God, I think X is trying to start an affair." The flirty friend is usually a deft calibrator of their hugs—a warm but not too sensuous squeeze-pat-release that somehow conveys sexual viability while denying sexual availability—but woe to the recipient who is not similarly skilled! It's so easy to mistake this hug for more than it is. It's so easy to take this hug as a low-key invitation to something seedy. It's so easy to have a moment where you do some quick mental calculus and find yourself weighing your irritation that your spouse still hasn't done the dishes against, say, your own wedding vows. Do not make these mistakes. Look, all I'm saying is: Don't kiss their ear. Just . . . just do not.

THE TUM-TUM FACTOR

Some of Us Were Built for Comfort,
Not for Speed

So many signals to read, so little time to read them. Everything—from an extra beat of eye contact to where you put your hands—is significant in terms of whether this night is going to culminate in sexual activity. Any factor that impedes these tiny, subtle communiqués can be disastrous—and thus we come to the Problem of the Pot Belly. Personally, I love a good pot belly. It speaks to a certain Falstaffian charm, and serves as an advertisement that this is a guy who might enjoy an evening of donuts and fucking (NB: I am happily married, but if I were not, DOWN FOR DONUTS AND FUCKING would 100 percent be my screen name). However, in terms of pure geometry, it poses something of an issue, forming a barrier between the pelvic regions of the hug participants and complicating the transmission of Mound Vibe Energy. It necessitates either curling your pelvis under like a shrimp's tail or mashing your bodies so firmly together that the belly is squished back, into the spine—solutions that are ungainly at best and painful at worst. The man blessed with a generous midsection is thus advised to rely on other signal inputs, much in the same way that a visually impaired person's hearing will sharpen to make up for the loss of sight. Try just holding her hand, you delicious pumpkin of a man.

THE BRO HUG

I'm Hugging You, but I'm Hitting You

Guys. GUYS. We see you. We see you out there, punching it in, gripping one another's forearms when you shake hands, circling the flame of human affection like skittish moths. We know your sense of self is deeply rooted in your successful performance of manhood. We see you clasping hands and yanking each other toward yourselves, reaching around to deliver one, two, three quick slaps to the back—all done hard and fast, as if speed and force can mask your raw need for love and approval. We see you, and we shake our heads in pity, because not only is it all so transparent, it also makes you look like a real douche. I look forward to a future in which men can hug freely, with real warmth, and without resorting to the pseudo-violent hug-hit with which they must protect their fragile masculinity. Assuming, of course, they have time to hug once they've defeated all the sentient robots that are almost certainly coming to murder us all. Anyhoo, get over it, fellas. It's just a hug.

THE "I DIDN'T RECOGNIZE YOU AT FIRST" HUG

Time Is a Real Bitch

This is one that comes with the added benefit of a long, awkward run-up to the actual hug—a few minutes of hard-to-interpret eye contact with some guy at the farmer's market, say. Is he admiring the cute little Madewell shirt dress you wear to shop for expensive strawberries? Or is he planning to murder you? Just as this tension ratchets up to the point where you might have to run screaming, it hits you—it's that guy your best friend dated sophomore year, that tall drink of water with the spiky haircut and the sleepy eyes. That hair, of course, is gone now, and he's grown a truly regrettable mustache to make up for it. No wonder you didn't recognize him! Mr. Hot Stuff looks like somebody's try-hard uncle (whereas you, you peach, look exactly the same, is that right?). Anyway, the protocol here goes something like this: high-pitched squeal of recognition, embrace in front of the strawberries ($12/pint, mercy), five-minute chatty catch-up, promise to connect on Facebook and get lunch sometime soon. You, of course, will do no such thing. I mean, that *mustache*.

FRIEND OF A FRIEND

Friendship Is Nontransferable

This is one that falls into the unfortunate "unearned hug" category. We've all run into someone we know tangentially on the street (or at Trader Joe's, for our friends in L.A. who are unfamiliar with the concept of sidewalks); perhaps you spent five minutes chatting with this person at your mutual friend's birthday party, or maybe this person just pops up in your "People You May Know" feed so often you forget you don't, in fact, actually know them. Either way, if you're a hugging sort, sometimes your arms just go up on autopilot, and there you are hugging somebody with very little in the way of context or justification other than MY BRAIN KNOWS YOUR FACE. And sometimes that's enough! But sometimes it isn't, and there you are, making an affectionate gesture toward someone who, for all you know, is a closet fascist. Best you can hope for is that you weren't caught in the act by the Google Maps car (or, for our L.A. friends, the Trader Joe's security cameras).

THE PANIC HUG

It Seemed Like a Good Idea at the Time

Years ago, I happened to run into the mother of my recent ex on the street. She was, to put it mildly, much more distraught about the breakup than I was, and to my absolute horror, she began to weep. Not having the slightest idea what to do, I panicked and did what I always did when her whiny little bitch of a son would weep—I hugged her. She was a tiny woman, coming up to only about my shoulders, and horror beyond horror, I found my hand resting on the back of her tiny head. "A little squirrel skull, she has a little squirrel skull," my brain chirped, helpfully. When I tell you I have never struggled harder to contain gales of wildly inappropriate panic-laughter in my life, know that that includes while being yelled at by my choir teacher, at a birthing class when I was pregnant, and at my grandmother's funeral. The lesson here is that hugging while panic-stricken is like trying to rescue a drowning person: chances are, this won't turn out well for anybody.

Family

HIPPIE UNCLE

Ugh

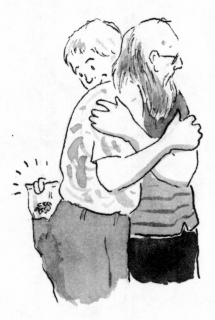

Almost every family has at least one member who fought their way out of Squaresville with dreams of starring in their own personal version of *Easy Rider*. Maybe your aunt Joanie spent a few years on a commune before winding up on her own little patch of dirt upstate after Rick and Sharon sold out to the dairy conglomerate. Maybe your uncle Dave has a lot of stories about throwing bottles at the pigs during the Haight-Ashbury riots.* Either way, chances are you've got a relative or three with long, gray hair, a collection of culturally appropriative shirts, and a genius for turning any household object into a bong. These relatives give hugs that seem warm and genuine at first touch, but have a coldly performative edge to them that leaves you wondering if maybe Dave and Joanie are just shitty, self-centered people who hide behind a tie-dyed veil of peace and love to get out of having to do anything resembling actual work. These hugs, or simulacra thereof, have a strong top note of patchouli. Suffer through it, and help yourself to some of their primo weed once they go down for their afternoon nap.

* Dave did no such thing; he hid behind a Dumpster eight blocks away from any action and considered going back to school for a law degree.

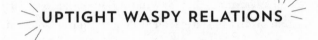

UPTIGHT WASPY RELATIONS

*The Least Emotional Physical Contact
Between Two People Possible*

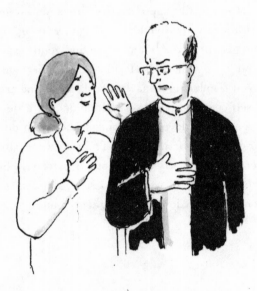

Have you ever wondered what it might be like to hug Whistler's mother? If you don't have any dusty *Mayflower* relics in your own family, go find your friend with the tasteful old Volvo and ask if you can come to dinner—the boiled cod won't be the only thing that's cold. Perhaps you're familiar with Hilaire Belloc's epigram in praise of the warm, sense-satisfying cultures of Southern Europe?

> Wherever the Catholic sun doth shine,
> there's always laughter and good red wine.
> At least I've always found it so.
> Benedicamus Domino!

This is not that kind of party. We're looking at something a little more like this:

> Wherever the Protestant sun doth hide,
> there's always work but never pride.
> And should you hug or laugh or loll,
> may God have mercy on your soul.

Needless to say, an embrace from one of these people is cool, stiff, and crackling with disapproval (and why wouldn't it be? Hugging is for fools and peasants, and these folks didn't survive four hundred years of New England winters and Puritanism by suffering either). Try this hug once just for the experience, and then leave the grounds as quickly as you can.

TODDLER HUGS

At Least They Don't Flee from You in Terror

This is how we wish we could all hug: joyfully, unself-consciously, and while taking a dump in our pants. Even if you hate kids, a hug from a toddler feels like a gift—a sticky gift, but a gift nonetheless—an endorsement from a person too young to judge you on anything but whether you're scary. It's hard to even make it awkward, because two-year-olds don't have emotional baggage (or if they do, said baggage concerns only sugar)—I say hard but not impossible, because if you hug a toddler and immediately start weeping because you remember when your kid was this small and now she's slamming doors and calling you a bitch to your face and man those toddler years were so tough, but what you wouldn't give for one more day where your child loved you with a pure and uncomplicated love and—yeah, yeah, there you go, you did it. You made hugging a toddler super awkward. Congratulations, Scary Aunt!

THE MOTHER-SON HUG

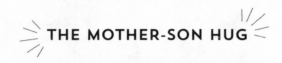

Like Psycho, *but Make It Fashion*

Here is a truth about parenting that doesn't get a lot of airtime: No matter how old your child gets or how emphatically they declare their independence, you never quite stop feeling some measure of custodianship over their bodies. It makes a kind of sense—you can't spend years wiping somebody's butthole without seeing them as a sort of extension of yourself, and the idea that at some point your access to their body would be denied is a hard one to wrap your head around. This is why mothers, despite the loud protestations of their adolescent offspring, are unable to refrain from hugging their kids. Another truth, inextricable from the first: Mothers have a deeply sublimated anger toward, and desire for revenge upon, their children, which is why they not only hug them, but hug them IN FRONT OF THEIR FRIENDS OH MY GOD MOM STOOOOOOP!!!! Yeah, that's right, right in front of your little skate-rat palsie-walsies. That oughta make up for what childbirth did to my perineum, you wispy-mustached, stink-pitted ingrate.

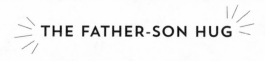

THE FATHER-SON HUG

Cue "Cat's in the Cradle"

f there's any reason to feel sorry for men in the Western world, it's this: Most of them are denied access to all but the most cursory forms of nonsexual physical affection. This starts in childhood: At some point in a boy's development, he reaches an age or height at which a hug from one's father is deemed "unmanly," "babyish," "sissifying." A real man shakes hands! A real man gives a terse nod of approval! A real man hides his feelings behind a double bourbon and the evening paper (by which I mean a vape pen and the news feed on his phone)! Happily, this embargo on hugs seems to be lifting (at least in some circles), but men are, by and large, a lot weirder about getting their emotional cooties on one another than they need to be (see: The Bro Hug). This is bad for boys, bad for men, and ultimately bad for women or anyone else who has to deal with the fallout of the affection starvation and emotional illiteracy that the average man has to suffer. It doesn't have to be this way! FATHERS: FOR THE GOOD OF THE WORLD, HUG YOUR SONS!

THE MOTHER-DAUGHTER HUG

I Don't Know Her

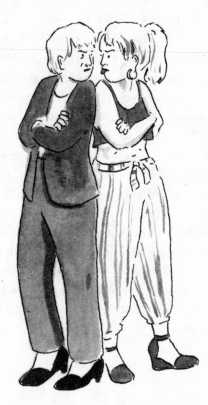

One of the most diabolical features of the patriarchy is how it divides women in order to conquer them. Two women in a male-dominated office? The patriarchy will ensure that they'll destroy each other. Two popular girls in one homeroom? Take out your stopwatch and see how fast one spreads rumors about the other. But the saddest casualty of this cultural poisoning is the relationship between mother and daughter—the daughter chafing under the mother's admonition to conform to societal female-coded expectations, the mother resenting the daughter for her youth and beauty. Gone are the delicious snuggles of childhood—once puberty hits, mother-daughter hugs are few, far between, and only executed under duress. All adolescents suffer the necessary trauma of becoming their own person, but there's something particularly cruel about how a daughter must sever herself from her mother, defining herself in no small part by being nothing—NOTHING—like that bitch. What I'm trying to say here is: I STILL RESENT YOU FOR NOT LETTING ME SLEEP OVER AT MY BOYFRIEND'S HOUSE IN HIGH SCHOOL, MOM.

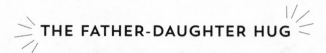

THE FATHER-DAUGHTER HUG

Just Give Me the Car Keys, Dad

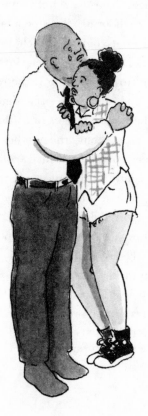

All hugs between family members take on a different tenor once a child grows up, and this one is no different. A little girl should, in ideal circumstances, be able to see her father as her protector, a man in whose arms she is unequivocally safe—but once that little girl hits puberty, the Daddy-as-protector vibe skews a little too Purity Ball for comfort (and if Purity Balls are your jam, you and I don't have much to talk about). Now Daddy is just that dork who has a bunch of records (that NOBODY CARES ABOUT, DAD) and tries to make you come home by 10:30 even though you told him a million times you're getting a ride from Elyssa so it's, like, not up to you when you get home, okay???? If Daddy—sorry, sorry, Dad—hugs you a little too hard sometimes, it's just because he wishes he could squish you back down to child size. Not because he can't handle you growing up and becoming a woman (with a body over which you have COMPLETE AGENCY, honey), but because, truth be told, he liked being your hero, and he misses it. That's all.

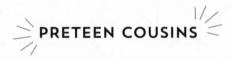

PRETEEN COUSINS

Aw, Somebody Get the Camera!

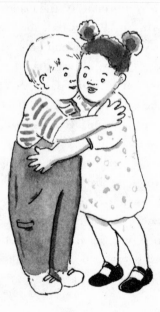

s there anything cuter than two kids hugging? Especially if those kids are related enough to form a strong family bond, but not so related that they're at each other's throats all the time? This is the stuff of generations of family picture boxes, of dedicated Facebook albums, of Instagram hashtags (#EllyAndJames4Eva). It's the kind of thing that makes the airfare to the family reunion (In Houston? In July? REALLY??) worth it, that makes you actually want to read the family newsletter your mom prints up on the church photocopier every year instead of immediately crumpling it into the recycling bin. You'll embarrass little James and Elly by showing these photos to their respective prom dates someday—remember when you used to take baths together? You two were peas in a pod! Just the cutest thing ever short of an army of kittens on a Roomba.

TEENAGE COUSINS

Delete All Those Photos Immediately

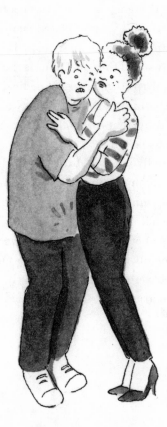

t stops being cute when James pops a boner. The end.

ADULT SIBLINGS

Must We Do This?

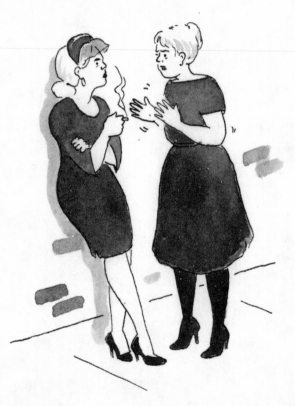

Look, just because you haven't talked to your sister in three years—ever since she trashed your then-boyfriend to your face and then made out with him behind the rose trellis at Staci-with-an-i's wedding, and then had the nerve to tell you it was your fault because you were always so critical, even when you were a kid, always little Miss Perfect, weren't you, and wouldn't apologize even when she sobered up in the morning, because she felt a *real connection*, which maybe she did, 'cause you heard she and what's-his-name dated for eight months after that, not that you ever talked to him again, either, and your uncle told you she stopped drinking, but that's just none of your business, and anyway you never got the twelve-step apology call, so fuck her—is no reason not to hug her; after all, this is your mother's funeral, MADELEINE.

THE GRANDPARENT-TEEN HUG

*Somebody's Got to Keep
Werther's Original in Business*

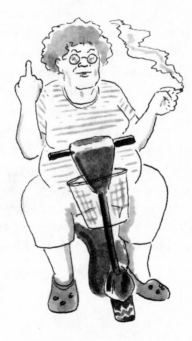

Dear teen:

By now you're old enough to know that despite her claw-like hands and terrifying smoker's rasp, Grandma is not *actually* a monster. Yes, she's still creepy, and that miasma of cigarettes and candy-dish mints will haunt your dreams for the rest of your life, but you're also old enough to know that if you don't hug her it's going to hurt her feelings, and if you hurt her feelings enough, well, let's just say Grandma has a *sweet* old Dodge Charger that could just as easily *not* have your name on it. So take one for the team, kid, and go give Grandma her hug.

Dear Grandma:

Lord, it's fun to watch 'em squirm, isn't it? Makes every last one of these wrinkles worth it. And fuck that kid, you're gonna be *buried* in that Charger. Smoke if ya got 'em!

THE OLDER PARENT–
MIDDLE-AGED CHILD HUG

"Cat's in the Cradle" (The Remix)

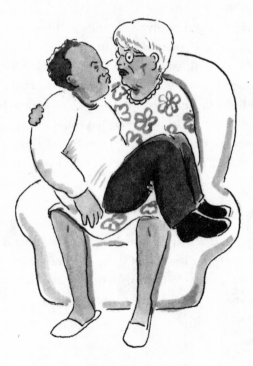

reat, now we're all old. You know how you feel all sad and sweetly nostalgic, looking at your frail, elderly parents? Those arms that used to toss you up into the air as you shrieked and giggled, now withered and covered in liver spots? Those twinkling eyes, now cloudy and dull? Huffing and puffing as they make their laborious way to the toilet to empty their papery husk of a bladder? Well, how do you think they feel looking at you, you tubby, graying non-baby? You used to be a delight, a wee speck of humanity they could protect and nurture, your dear baby face gazing at them with unconditional love bordering on hero worship. Do you know how old it makes your parents feel to look at their dear sweet baby and notice that he's gone *bald*? You think you hate your crow's feet—just imagine how your mom feels about 'em. Anyway, everyone's time is clearly short, so go ahead and hug it out. Just try not to break a hip, any of you.

Work

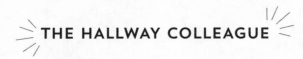

THE HALLWAY COLLEAGUE

What's-Her-Name Needs a Moment

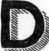espite the best efforts of the modern office to scrub every last smear of messy humanity from the environment, certain ancient truths hold sway. One of the most indelible of these is the instinct to commune with your fellow human near a source of water: the bathroom, the office kitchen, and, that gag-cartoon staple, the water cooler. You will find that some of your office acquaintanceships take place exclusively in these common spaces, forming a bond with hard-to-define parameters—something like a friend, but also something like a friendly tree you enjoy seeing every day on your walk to work. What to do, then, when it is clear that one of your water-cooler non-buddies has been crying? Do you pretend to not notice? Do you enquire, sotto voce, if they'd like to talk about it? Or do you defy office protocol and hug this office crier? Choose carefully, bucko, 'cause you give one little sympathetic hug and all of a sudden Brienna wants to loop you in to her Rebels of Weight Watchers group text.

THE CUSTOMER/CLIENT

Transactions Are Difficult

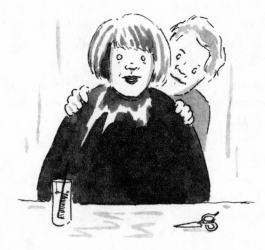

The question of whether you should ever hug a client or a customer is a thorny one, and depends at least in part on what good or service you sell. Are you a hairdresser or a nail technician? Chances are your client tells you things they'd never utter outside a confession box, and possibly not inside one either. A hug, should you choose to deploy one, is almost certainly welcome (if for no other reason than to celebrate the fact that Sherrie *loves* her new chunky highlights). Are you a nanny? I mean, I guess you have to hug the children, unless you're a governess, in which case you mustn't ever. But do not hug the parents, because you are being paid to love the CHILDREN AND THE CHILDREN ONLY. Do you work at the DMV or the post office? Those thick walls of bulletproof glass are there for *everyone's* protection. Look, if you're in any situation where money's going to change hands, just read the room and err on the side of caution.

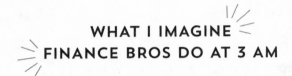

WHAT I IMAGINE FINANCE BROS DO AT 3 AM

Bring It In, Baby Gordon Gekko

The brutal dog-eat-dog world of Wall Street, where having a home life you care about is a sign of weakness and eighty- to one-hundred-hour workweeks are a given (the economy isn't gonna wreck *itself*, guys), breeds a particularly virulent strain of dude—a hypercompetitive, money- and power-obsessed, morally bankrupt super-bro. But after hours, when even the cleaning lady has left the building (saying nothing about what she saw, sir), and a few hard-core gentlemen remain, pounding away on the numbers from Hong Kong or whatever market's open, I like to think that Chad turns blearily to Bret and whispers a hoarse "Bro?" at which point they stop what they're doing, and Chad puts his head in Bret's lap and sobs for fifteen minutes while Bret strokes his prematurely thinning hair and makes comforting noises. They switch places, and then they clean themselves up, wipe their eyes, hug it out, and blow a couple of fat rails off the desk that Evgenia *just* cleaned because, after all, there's no point in going home *now*, right? It almost makes you pity them, before you remember, you know, *everything* about them.

Oddly, because these people have no shame, this is the *least* awkward hug in this entire book.

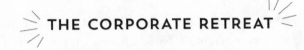

THE CORPORATE RETREAT

What Happens in Denver
Stays in Denver

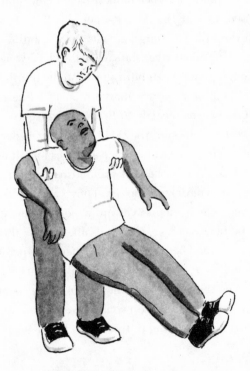

There was a time when a job exacted from you only what it could get between the hours of 9 AM and 5 PM, and it demanded nothing in terms of emotional duty beyond a willingness to work hard. Those days are long gone, supplanted by workplaces that scoff at a mere forty hours a week, that require a spiritual alignment with the corporate ethos, and, most regrettably, eat up your whole weekend with some bullshit "team-building" getaway where you're expected to do trust falls with the kind of people who steal your Lunchables out of the fridge. The corporate retreat forces a kind of intimacy normally reserved for family and close friends. Inevitably, there is physical contact. Trust falls are just a gateway drug to the kind of embrace that has you sobbing in Candace from Marketing's arms after unearthing some truly ancient baggage involving Beanie Babies. Will this bring you all together? Or will this be a *Breakfast Club* situation, where you go back to ignoring one another in the hallways, because, like, who's *really* going to hang out with the dweeb? Only time will tell, but meanwhile, you better hope Team Red keeps their collective mouths shut about all the truth you shared at Campfire Time. Some of that shit was *actionable*.

THE HOLIDAY PARTY

3 AM Booze-and-Panic Sweats

ook, you hugged a *lot* of people at that party. I know, I know, you always tell yourself that this time, THIS TIME, you're gonna pace yourself. You're gonna drink water in between drinks, you're gonna load up on carb-heavy, booze-sponge foods, you're gonna *keep it together.* But social anxiety is a beast that can only be shushed by bourbon, am I right? And maybe you had some very earnest conversations, like the *real talks* you never get to have in an office setting or really almost anywhere now that all your friends are married all of a sudden, and once they have kids, forget it, you're gonna have to start taking a pottery class or some shit just to have some nonwork human contact in your life. And maybe the gratitude you felt for just being seen and talked to like a *person* instead of a walking Alexa came out in the form of deeply felt hugs. With—or *at?* It feels like maybe you were hugging *at*—oh, man—a lot of people. Definitely Mike, but he's cool. For sure the kid from the mail room. Possibly one of the senior editors. Yes, definitely one of the senior editors. More than one of them? Oh, sweet Jesus, did you hug the publisher?? Oh, no. Oh, nonononono. Text Mike and find out exactly what you did. Don't use too many emojis. Did—oh, okay, you did hug the publisher. Oh, fu—oh, wait, she was drunk, too? She barfed in a wastebasket? *Next* to the wastebasket? In front of the *Page Six* guy?? And here you thought you wouldn't get any Christmas presents.

BUSINESS PARTNERS FROM LANDS WHERE THEY DO THINGS DIFFERENTLY

Or, the Eurohug: Is It a Thing?

I write these words as an American (and perhaps you're reading them as one, if there still is an America by the time this book comes out). While we here in this country might lack a commonly agreed-upon modus operandi when it comes to physical expressions, there are places in the world where they have things like "customs" and "protocol." First off, chances are good that the occasion of a visit from the Brussels office isn't a real good time to get huggy—workplace customs are fraught enough without the added potential for cultural misunderstanding. But what *do* you do? Herewith, some highly subjective and unscientific guidelines.

Europe, Northern: These people will happily get completely starkers with you in a sauna, but they're not especially physically demonstrative. I know, I think it's weird, too.

Europe, Southern: Red-wine people tend more often to be cheek-kiss people. This freaks Americans out, because we don't know how to kiss anything that isn't a baby without spinning out into a Puritanical lust-guilt cycle.

Russia: That's not a hug, they're just patting you down to check for wires.

Asia and the Middle East: These countries have been practicing social conventions since before Europe even got it together enough to die in droves during the Black Plague, so fucking do some Google research and try not to screw it up too badly, you barbarian.

Australia: These people will hug, arm-wrestle, back-slap, whatever. Think of them as Americans who know a lot about bugs.

Africa: It's a big place. Find out what country your visitors are from, Google it, and then default to shaking hands like you always do.

Latin America: Also cheek-kiss people, but often just the ONE cheek. The disaster here is when you think you're being culturally correct, but you forget that you don't kiss the other cheek and wind up smacking your forehead straight into the forehead of the person you're trying to greet, making the idea of a "first impression" regrettably literal.

Canada: Do whatever you want to these people, they're too nice to say anything. Tell 'em butt-patting is a time-honored (honoured!) tradition in your state/city/men's club, and they will fall all over themselves trying to lay their paws on your bottom, no matter how much it's killing them inside.

Canada but Quebec: WARNING: THESE ARE DOUBLE CHEEK-KISS PEOPLE YOU THINK THEY'RE CANADIAN BUT THEY'RE NOT THEY WILL NOT FALL FOR YOUR TRICKS USE EXTREME CAUTION.

England: Sweet Jesus, don't touch the English. The only way to win the affection of an English person is to land a particularly nuanced insult, and they will express that affection by drinking you under the table at some absurdly early evening hour.

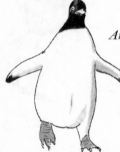

Antarctica: AAAAAAAAAH IT'S A PENGUIN!!!!! HUG IT, IT'S THE CUTEST THING!!!!!

All the Rest of Life

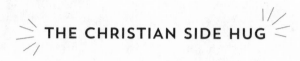

THE CHRISTIAN SIDE HUG

Even Jesus Is Rolling His Eyes

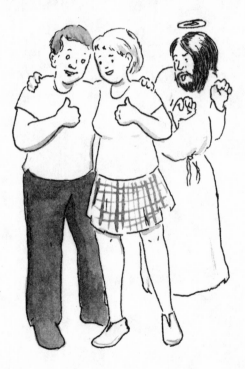

Reader, it is my unhappy duty to remind* you that there exists a "rap" video entitled "Christian Side Hug," a satirical but-not-really paean to the Evangelical practice of embracing side by side rather than front to front, lest the huggers be tempted by junk in proximity to junk. A decade ago this video took the Internet by storm, the earworm we all loved to hate. It's a study in cultural appropriation and idiotic logical extremes, and I am very sad that I looked it up in the course of researching for this book, because now YouTube thinks I'm into this kind of thing and is serving up additional God-botherer content despite the fact that it should know I'm really only there for the ASMR and Nick Cave videos. I say this as a practicing Episcopalian: Side hugs are bullshit, and if you think a regular hug is going to throw you into a tizzy of uncontrolled lust, I gently suggest you seek counseling for your sexual dysfunction.

* If this is the first you're hearing of it, well, now we can all suffer as one.

THE FAILED TODD HUG

Hi, Todd!

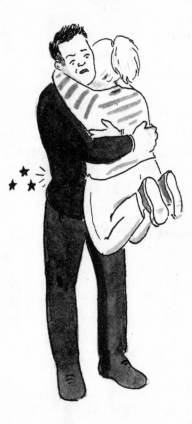

My friend Todd is a tall man, built like a rugby player (though as far as I know, the only competitive sport he plays is smoking). He was in the habit, whenever we would meet, of wrapping me in a bear hug and lifting me fully off the ground like I was a child and he was my dissolute but fun-loving uncle. I enjoyed this—I am not a small woman, and being tossed around in a loving way made me feel delicate in a way I rarely get to experience. The dark inverse of this, however, is the point at which you're not so toss-aroundable anymore. The last time I saw Todd, the man had to put his back into it in a way that called out every extra inch around my waist by name. We all know the difference between a grunt that emphasizes a hug and a grunt that signals effort, and if I didn't before, I sure do now. Is my middle-aged spread to blame, or Todd's middle-aged back? I can't tell you for certain, but either way, a hug that neatly demonstrates the ongoing degradation of your fleshly self is a real *thing*.

THE BOOB-JOB HUG

Mind the Investments

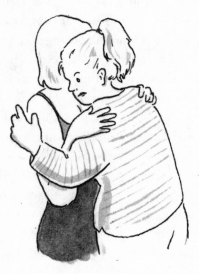

I once had the opportunity to hug a celebrity (I'm not naming names, but buttonhole me in private and I'll absolutely tell you who) who had breast implants, and I came away truly impressed by the deftness with which she interpolated her elbows between us to avoid the possibility of my squeezing her too hard, and thus potentially damaging the ladies, while still managing to impart a real warmth in her embrace (she also smelled nice, like vanilla with top notes of something expensive). This is no shade on the fake-tittied among us—trans women, breast cancer survivors, ladies who just plain want different boobs: as Our Lady Cher has noted, if you get tits on your back it's nobody's business but your own, but it is worth noting that one might need to be more mindful of the squeeze if there's silicone underneath. After all, not everyone has the wizard-level ability that my Unnamed Celebrity did to calibrate your hug for you. Hug gently!

THE GROUP HUG

Oh, God, Not This

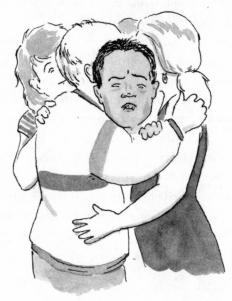

hy be awkward in a pair, when you can up-grade to the three-dimensional awkward-ness chess that is the group hug? A staple of summer camps and family reunions the world over, the group hug is a clusterfuck of limbs, pits, body odor, and hair in your nose. I would honestly rather have group sex, and I have little to no interest in group sex. You can get out of both by backing away quickly and telling everyone you have the clap.

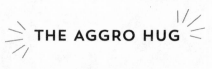

THE AGGRO HUG

I Get It, Dude

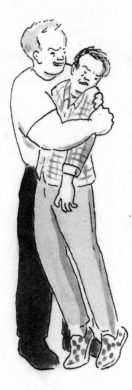

A cousin to the aggro handshake, the aggro hug is a hug designed to convey the opposite of what a hug is usually for: rather than expressing kindness, affection, and warmth, the aggro hug is a display of power, of potential force, domination masquerading as friendliness. It shares some DNA with the bro hug—there's usually back slapping involved—but the aggro hugger is not shy about really leaning in to that squeeze, because he (yeah, it's always a he, sue me) wants you to *really understand* how easily he could snap you in half like a twig. Gross!

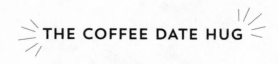

THE COFFEE DATE HUG

These Ain't Just Caffeine Jitters

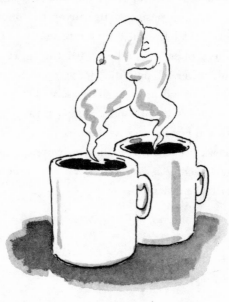

s there any lower-stakes social engagement than the coffee date? It's quick, it's easily planned, and it avoids the terror of eating in front of someone you're only just getting to know. (That's a thing, right? It's not just me?) A quick cuppa, a chat, a mutual acknowledgment that this particular coffee chain over-roasts its beans, *maybe* a shared muffin. Perfect! And then it's time to get up and say your goodbyes, and this is where the easy date gets positively treacherous. In a perfect world, you walk out together, give a quick and pleasant hug, and stroll off in opposite directions—but if this was a perfect world, well, this book wouldn't need to exist. Ready yourself for an awkward jumble of chairs and bags, glares from the guy on his laptop you just bumped into, the weird thing where you hug over the table you just had coffee at, worrying about your awful coffee breath, and, of course, experiencing a sudden disastrous need to take a shit.

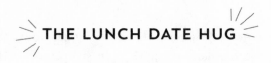

THE LUNCH DATE HUG

Keepin' It Caszh

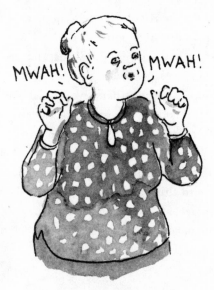

This is the second-semester version of the coffee date hug, reserved for newish friends and business associates who will be billing this back to the company. For better or worse, it's not 1960 anymore, so if this is a three-martini affair, you're either charmingly retro or you have a drinking problem (or both!), so chances are you can't rely on alcohol to smooth the social edges nor provide you with an excuse if things go tits-up in a ditch. The upside is that "lunch" implies a rest of the day to get back to, whether that means returning to the office, going to pick up your kids, or going back to bed and spending the afternoon in a Valium haze, which relieves both parties of the pressure of having to dance around what happens *after* you eat. However, a lunch date is usually at least somewhat performative—you're either trying to solidify or rekindle a friendship, or impress, say, an editor or agent with your midday wit and charm, and it's entirely possible to crush this lunch and then fail, spectacularly, to stick the landing by fucking up the hug. Just do what I do, and screech, "AIR-KISSES!" while doing a big, showy *mwah-mwah* on either side of your companion's head. Sometimes the only way out is *all* the way through.

THE DINNER DATE HUG

And You Thought Splitting the Check Was Awkward

f all the two-person-plus-food outings in this lineup, the dinner date is definitely the most fraught. It's unlikely to be a professional thing—and if it is, hoo, be careful with those cocktails, champ—but definitely likely to have a romantic angle, which gives the hug question a whole extra dimension. This is a hug that must be calibrated with the utmost of care—will it be a "thanks for a nice evening, but I have zero interest in banging you and will presently be going home to take off this fucking bra and catch up on my Instagram Stories" hug, or a lingering "let's have some payoff on this fun sexual tension" hug? How rare it is that both participants are on the same page about this, and how often the hug curdles into a flesh trap of mis-read signals. When all else fails, claim sudden-onset food-poisoning and run for the subway.

THE "OH, NO, YOU DIDN'T WANT THAT" HUG

Still Kicking Myself

I was recently on a stand-up show that went really well—every act was phenomenal, a bunch of truly hilarious ladies, only one of whom I'd known previously. At the end of the night, I went to hug one of my new funny lady friends, only to realize *as my arms went around her* that she had no interest in receiving this hug—she froze stiff as Han Solo getting the carbonite treatment. It was too late to pull out without it seeming like an act of revulsion, so I just squeezed as quick as I could and made my retreat. Friends, I felt awful about this. Determining whether a hug is welcome is sometimes a matter of reactions clocked in nanoseconds, and realizing your error as you wrap your arms around a frozen person is a bad scene (and a worse scene for the person receiving the hug). This all, like so many things, could most likely be solved, or at least ameliorated, by asking first. Maybe "Can I hug you?" should be the new "Can I pet your dog?"—saves everyone from getting bitten and/or sued.

THE "YOU DIDN'T WANT THAT HUG, BUT I'M GIVING IT TO YOU, ANYWAY" HUG

The Spite Hug

The dark side of the unwanted hug coin, this is one to be deployed judiciously. It is not a hug that should ever be given by a man to a woman, say, or by a boss to an employee—this is a hug that is all about subverting power, not wielding it. If you have any rich or famous friends, or, better yet, friends who have *become* rich or famous since you've known them, and you'd like to stick it to them, *just* a little bit, this is the hug for you. Squeeze 'em like you're trying to distract them while your partner steals their wallet. Try not to have showered. Go in hard and get your poor, non-famous cooties all over them. Who in the hell do you think you are, anyway, MIKE?

THE ROCK-PAPER-SCISSORS OF PHYSICAL CONTACT

Shrug Emoji

You are bidding an acquaintance goodbye after a pleasant chat. You, a hugger, are going in for an embrace. Your acquaintance, not a hugger, is going in for a handshake. Thus we come to a tiny pocket of time and space where something as innocuous as a "See you later" can abruptly devolve into a fistfight as your friend's outstretched hand accidentally punches you in the gut. This is a situation particularly common in intergenerational or intercultural goodbyes—the hug versus handshake, the air kiss versus fist bump. What's needed here is a culturally agreed-upon hierarchy of physical demonstration and a commitment to taking two seconds to decide the terms. When saying goodbye, the protocol should include a quick showdown to determine the form. I'm going with fist bump beats air kiss, air kiss beats handshake, handshake beats hug, hug beats fist bump—but I am not in charge, so this is all pretty moot. Just keep flailing and inadvertently hitting each other—it's the American way.

TALL/SMALLS

The Mutt and Jeff Hug

nless one of the huggers here is a child (in which case, pop a squat and get on that kid's level, my dude, have you ever even *met* a child before?), this is a hug that poses an interesting physical quandary: What actually goes where? The shorter person in the combo is all but required to clasp the taller person around his waist, stirring up a Daddy vibe that may or may not be pleasant, depending on personal history. The shorter person also has the option of going up on tippy-toes to hug the taller person around the neck—this can be charming, but proceed with caution, as it is not a move for the clumsy. If the woman is taller, the potential for a face-boobs collision is very, very serious. The only thing to do in that case is lean all the way in and motor-boat the hell out of—KIDDING KIDDING KIDDING. DO NOT DO THAT. The absolute only situations in which motorboating is okay is if you have been explicitly invited, or if you are two lady friends who have seen each other change a tampon. That's it. If a face-boobs mashup is inevitable, turn your cheek to the side and don't be weird about it. Tits are very nice and generally make good pillows, but try not to make a nap out of it. If the tall woman is not wearing a bra, do not try to defuse the tension by making a little joke about it. You will only make everything much, much worse. Trust me. In any case, I find best practices in this situation to be for the taller party to place the smaller on his or her shoulders for a full Master Blaster, thereby turning a potentially awkward hug into a party at the Thunderdome.

THE BIG HAIR HUG

The Ozone Hole of Awkward Hugs

This is, hands down, one of the ten worst things that can happen in a hug situation. You've got an older distant relative, let's call her Jenny. Jenny wears perfume that smells like the skid of knock-off Bonne Bell body spray they had by the door of the dollar store where you grew up, and always has just a little lipstick on her teeth. Jenny's hair achieved maximum volume in 1988 and has maintained it for thirty years, a crispy nimbus that resists all forms of gravity (but not flames!). You see Jenny every couple of years at one family thing or another, and this year, you made your fatal mistake—you failed to fully close your mouth when she went in for the hug, and you wound up with a mouthful of Aqua Netted, frosted-tip Jenny hair. Have you ever licked an old stuffed animal? Well, now you'll never need to, because you know what it's like to have stiff, dead-feeling bristles breach your oral perimeter, and it's a sensation that, once felt, you never quite stop feeling. Just know that you will never again be able to see a photo of people lounging on a bearskin rug without imagining the fur in your mouth, and shuddering with your entire body.

THE ABSOLUTE WORST HUG I HAVE EVER RECEIVED

Remind Me to Find a Therapist

've had my share of unpleasant hugs—no one who lives on this planet hasn't suffered through at least one or two—but I am sorry to tell you that the absolute worst hug I've ever experienced came at the hands (arms, really) of my own father. We have neither time nor space to explore the screwy dynamics of my family of origin (see my next book, *That Was Rage-Inducing*), but I can tell you this: The hug took place in my sister's kitchen over the holidays a few years back. I dropped something and bent over to pick it up, and my father materialized out of nowhere to hug me from behind, draping himself over my back in a way that felt both wildly inappropriate and physically dangerous. Annoying, yes, and icky, certainly, but the murderous rage that swept through me as I scrambled out from under him and screeched, "What are you DOING?!?! NEVER EVER FUCKING DO THAT AGAIN!!!" was, in retrospect, probably somewhat disproportionate. When you're angry at your parents, it's never quite about the situation at hand, is it? Ho ho ho, families are terrible.

THE IDEAL HUG

A Girl Can Dream

t is my sincere hope that you have at least one friend in your life into whom you can sink gratefully, relaxing into their embrace as fully as if they were your mother and you were not riddled with mother issues. When I was a child, I used to read the Aunt Beast sequence in *A Wrinkle in Time* to myself over and over—Meg's experience of a healing, boundlessly empathetic embrace filled me with exactly the sense of comfort and peace that a truly loving embrace can provide. Obviously, it isn't fair to compare regular human hugs with magical hugs given by fictional aliens, but that feeling stands as an example of what I would, ideally, like to both transfer and receive in a Really Good Hug. In an ideal situation, a hug is a way for two people to tap into the source of everlasting love and fellowship, their bodies forming a conduit to a wellspring of universal kindness. NO PRESSURE, though!

But How Do We Fix This?

///////////////////////////////////

A truth I am forever forgetting and having to relearn is this: We are *all* here in the Weird Feeling Thunderdome, all our friends who seem so easygoing and well adjusted *also* lie awake at night wincing in horror at something they said or did, and *everyone* has at least one story of a hug gone terribly pear-shaped. And this, I think, is the only antidote to awkwardness: empathy. When we are feeling awkward, we are imagining ourselves to be special: alone in our wretchedness, singularly incapable of stammering out a greeting without sounding like a total ding-a-ling. None of us are unique in our awfulness. This voice that tells us that we are comes from a fun-house version of narcissism—a fear rooted in our focus on ourselves and on our inadequate performance of the role of human

being. In the rare—rare!—moments of grace when I am able to remember this truth, it is immediately helpful. My internal dialogue switches from "How am I going to fuck this up?" to "How can I help this fellow sufferer?"—and my interactions are better for it. This is by no means meant to be prescriptive—not only is "Just stop being that wrong way that you are!" the worst kind of advice, but also taking advice from me on how to be more socially adept is like asking a toddler how to do trigonometry. But I can tell you, as a person with forty-plus years of experience as an awkward person, that finding empathy in your heart is as close to a social cure-all as I have been able to find. Be kind. Love one another as best you can. If you can hug with your heart, your arms should more or less sort themselves out fine.

And one last thing:

In general, do not hug the deli man. Either he will take it as a come-on or, and much more likely, you are the sixteenth drunk asshole he's seen tonight and he is DONE with it.

Appendix

HUG-FREE ZONES

Places Where You Should Never, Ever Hug

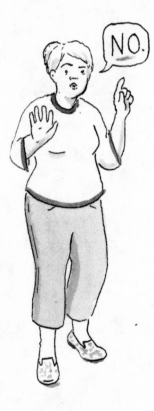

The Gym: Do you like being covered in another person's sweat? Like, not in a postcoital way? Of course you don't, any more than you would like being covered in any other human effluvium in a nonsexual context. (Weirdly, the only body fluid that stays gross even during sex is snot. Why is that? Oh, God, there's a whole Internet subgenre of snot-porn, isn't there?) There's just no reason to hug at the gym. If you're having a heart-to-heart on the elliptical—and really, you shouldn't be—just gently suggest that you take that conversation to somewhere with better lighting and less clanging. If it's that important, it'll hold until after you shower.

Sauna or Steam Room: If you missed the 2007 Viggo Mortensen gangster flick *Eastern Promises*, allow me to set up a pivotal scene for you: Viggo Mortensen's character, Nikolai, is relaxing in a sauna when he's set upon by two Chechen hit men. The Chechens are dressed, Viggo is not.* The whole scene is very bloody and slappy and wet, and you see a *lot* of Viggo Mortensen's dick. But if this scene taught me anything, it's that (a) Chechens are inept assassins, and (b) no physical contact should take place in a sauna, ever. Even

* You think that's gonna be a good time, but it isn't.

sex would be unpleasant—so much echo, so little control over what gets slippery when. Have you ever been to a Russian bath? Nobody so much as makes eye contact. And it's not out of shame, it's out of an understanding that the sauna is a place for a human being to be utterly alone with his or her thoughts even if the room is filled with other bodies. Don't fuck up the vibe.

The Locker Room: Actually, you should totally hug in the locker room, but only after you've ascertained that no one else is in there, and only as a prelude to boning in the locker room, because FUN. Also, either both of you should be coaches, or neither of you should.

The Crowded Elevator: If you do ANYTHING with your arms in an elevator other than keep them pinned tightly to your sides so as to take up as little space and cause as few misunderstandings as possible, you need to go home and ask your mother why she failed to train you properly. I don't care if your best friend from high school *who you thought was dead* gets on the elevator— you wait until you're no longer in a moving box with a bunch of people from HR who hate your guts. My God, can you imagine if you hugged someone in an elevator and then got stuck in the elevator? Honestly, it would be better if the cables

snapped and you died having your trachea punctured by Sheila from Accounting's femur.

Anywhere That Involves Both Long Lines and an Acronym: The DMV. TSA. PTA after-school sign-up. Bureaucratic domains are no place for affection, or joy of any kind. Chances are you're not there with anyone you want to hug, anyway, and even if you are, save that for the privacy of your own home. Furthermore, not only are the chances practically nonexistent that you'll want to hug the human cauldron of anger and regret doing your paperwork, you are also more than likely prevented from doing so either by a thick sheet of bulletproof glass or several federal and state laws. Fix your face into an expression of resigned boredom and look at your phone like a normal person.

Acknowledgments

I'd like to thank Brian Tart, the human beacon of joy that is Amy Sun, and everyone at Viking and Penguin; my gorgeous powerhouse of an agent, Meg Thompson; and John Hodgman (he knows why). I would also like to thank everyone who excitedly told me their worst awkward hug stories and endured the hugs I've inflicted on them over the years. And last, I want to thank John and Tug, without whose loving arms I would be eternally cold and bereft, and whom I adore beyond all measure. Thank you.

Emily Flake's cartoons and humorous essays run regularly in *The New Yorker*, *The Nib*, and many other publications. Her weekly strip, *Lulu Eightball*, ran in alt-weeklies for many years. She's written and illustrated two books: *These Things Ain't Gonna Smoke Themselves* and *Mama Tried*. Her illustrations and cartoons appear in publications all over the world, including *The New York Times*, *Newsweek*, *The Globe and Mail* (Toronto), *The Onion*, *New Statesman* (London), and *Forbes*. She lives in Brooklyn, New York, with her husband, daughter, and a frail, elderly orange cat.